Fun to Draw Mangamon

T. Beaudenon

IMPACT
CINCINNATI, OHIO
www.impact-books.com

The word mangamon is a contraction of the words "manga" and "monster." It is meant to designate the frantic, imaginary little creatures who accompany our favorite heroes on their adventures. Created in the beginning for video games, mangamon today occupy an important place in the universe of manga. You can find them in comic books, card games and many other places too!

These fantastic beings, often gifted with magical powers, are both pets and heroes to their own stories.

In this book, you will discover how to draw these little funny beings, and you can invent your own manga stories!

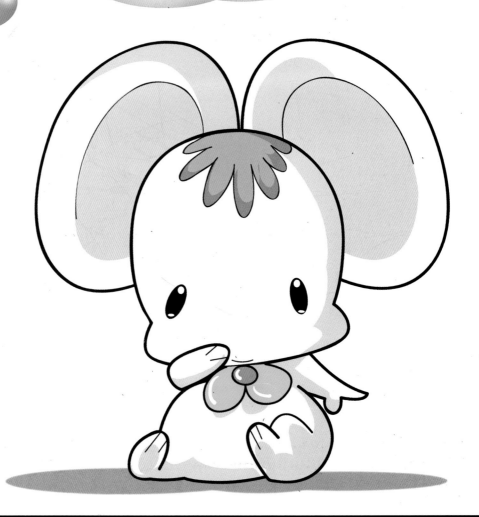

It's Fun (and Easy) to Draw Mangamon!

Here's the method that we will use to create your mangamon. We will use just seven or eight stages, depending on the level of detail, to draw a nice monster.

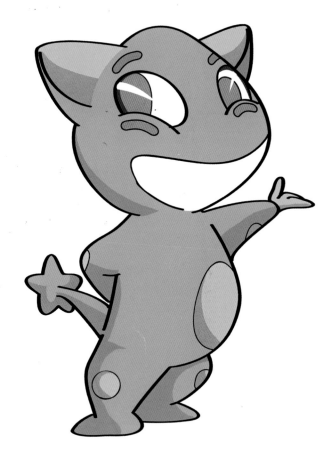

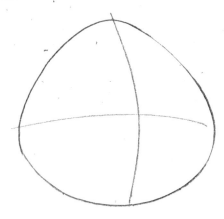

1 Start by drawing a head in the form of a crushed egg. Trace two lines: a vertical and another horizontal, to help later place the eyes and a mouth.

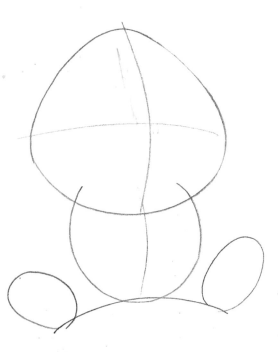

2 Adjoin a round form to the head to be the body, then start the legs based on a curved horizontal line.

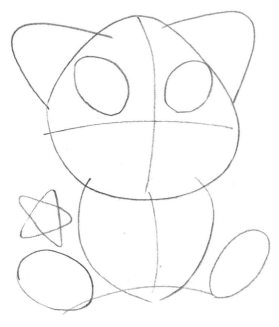

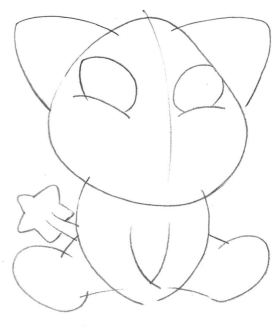

3 Now place the eyes, sketch the ears, the tail and the rest of the features.

4 At this stage, start to clarify your drawing a little bit, adding detail to the legs and the tail.

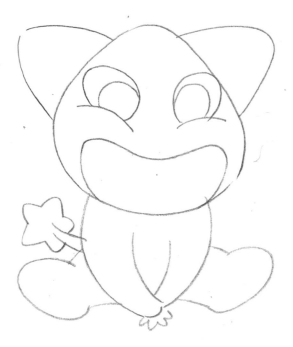

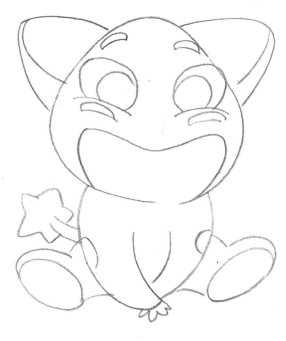

5 The drawing is beginning to take form! Erase unnecessary lines and start to add detail to the eyes, the mouth and the rest of the features.

6 Add the last details before darkening or inking the lines in your drawing.

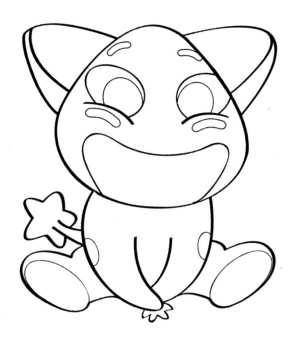

7 Go over the pencil lines with a black felt pen or other inking tool. Once the ink has dried, erase the pencil lines with an eraser.

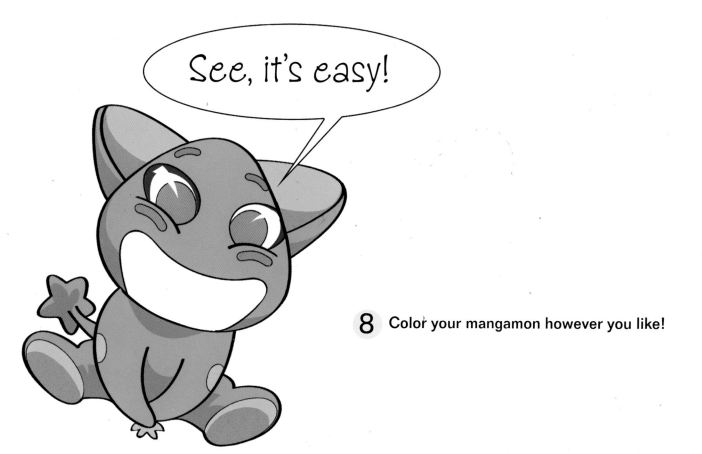

See, it's easy!

8 Color your mangamon however you like!

Tigrok

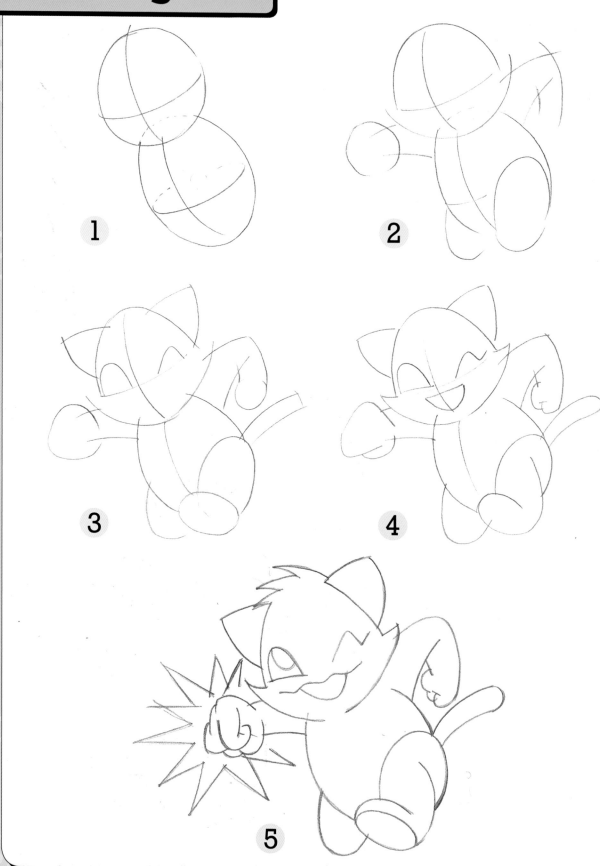

1

2

3

4

5

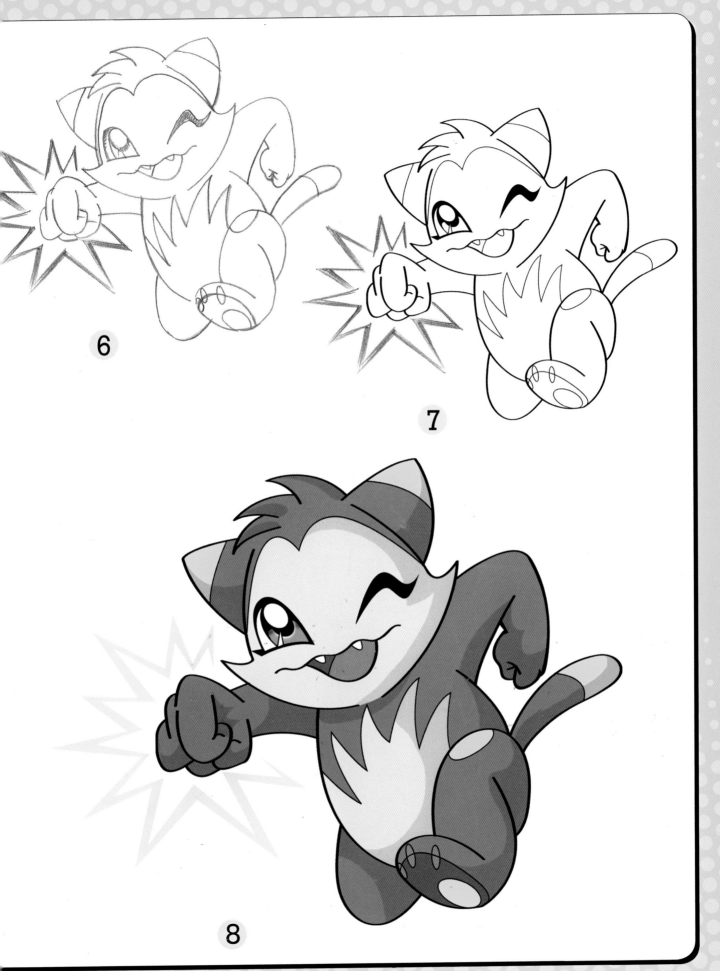

6

7

8

Scorpix

1

2

3

4

5

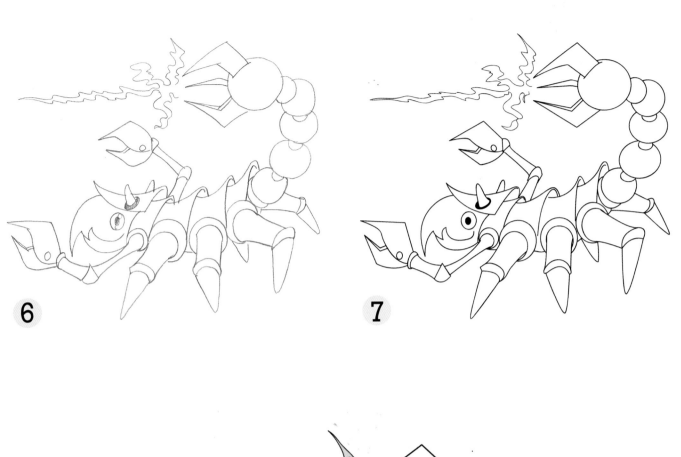

6

7

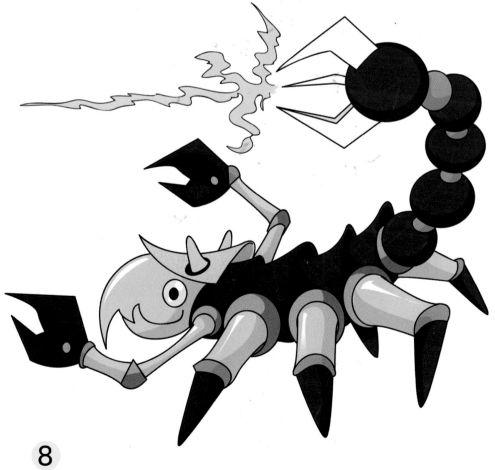

8

Sanglibek

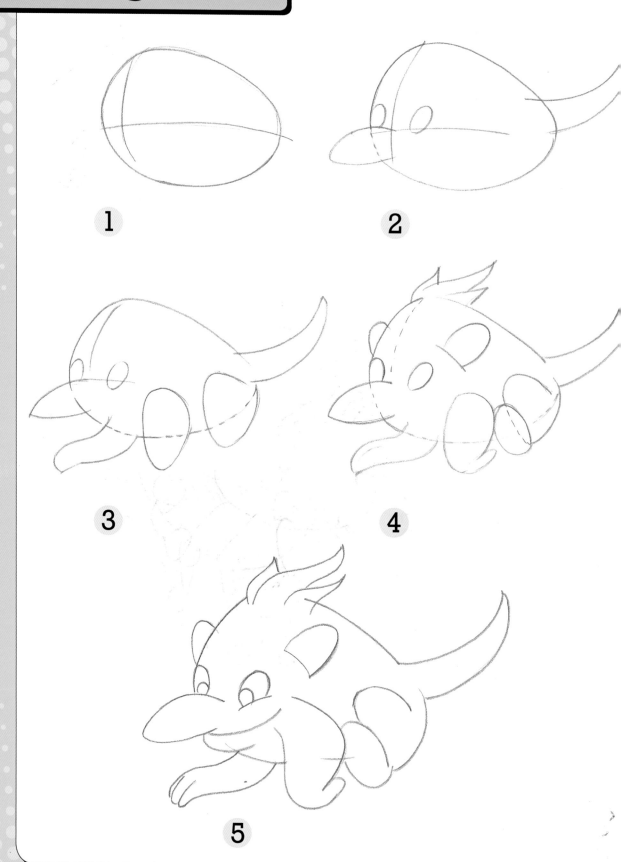

1

2

3

4

5

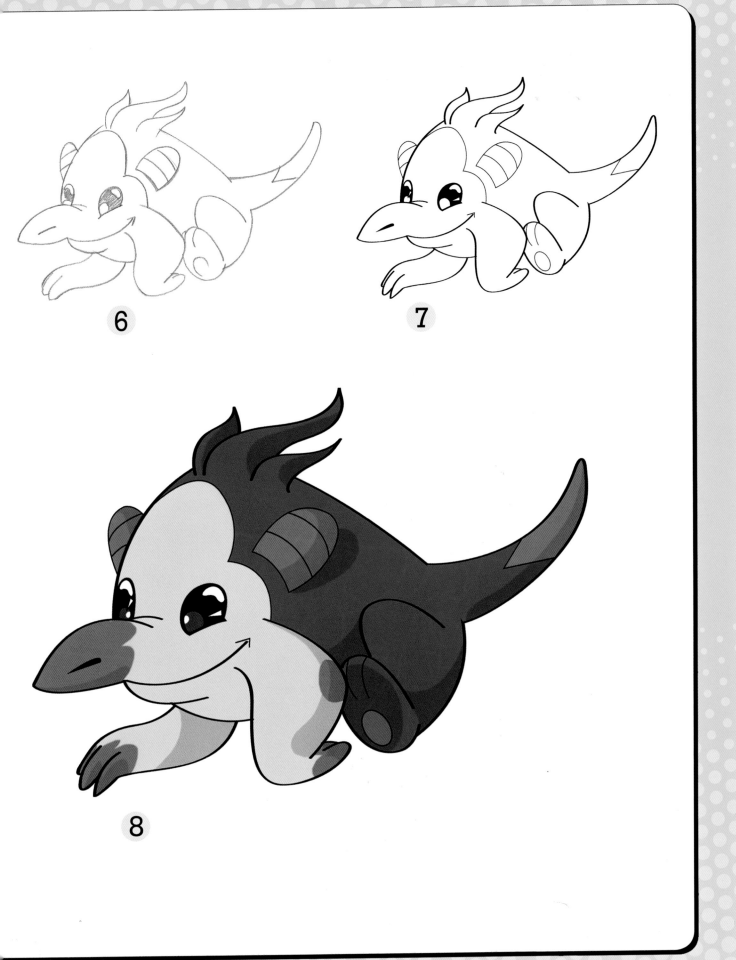

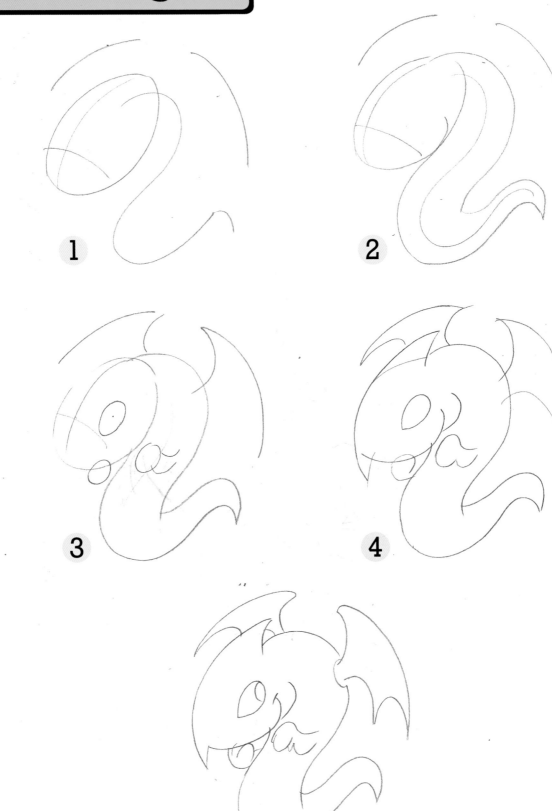

1

2

3

4

5

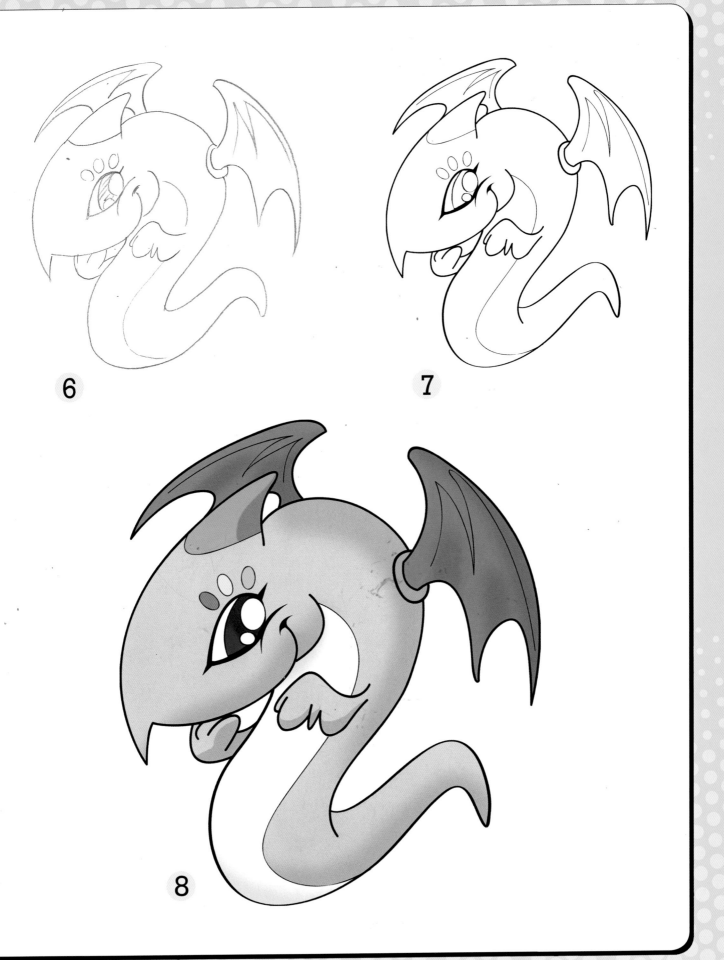

6

7

8

Lapi-Hapy

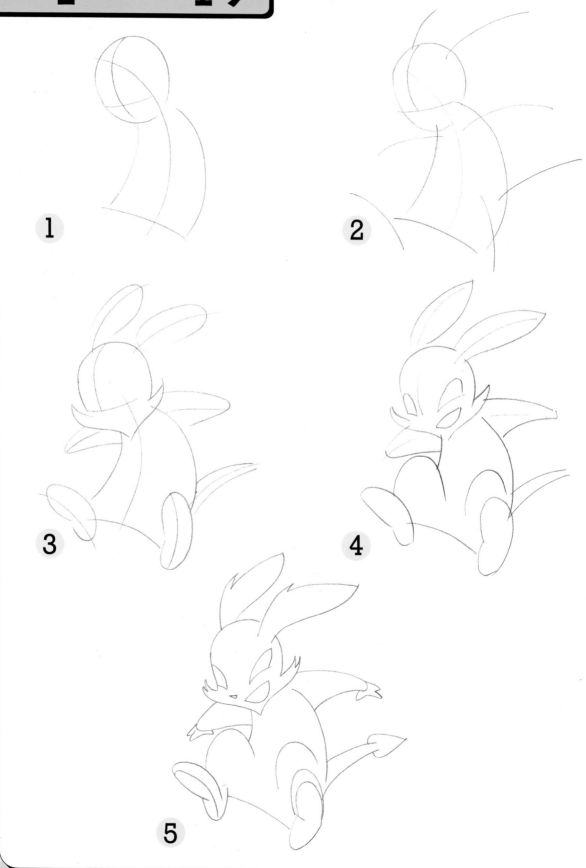

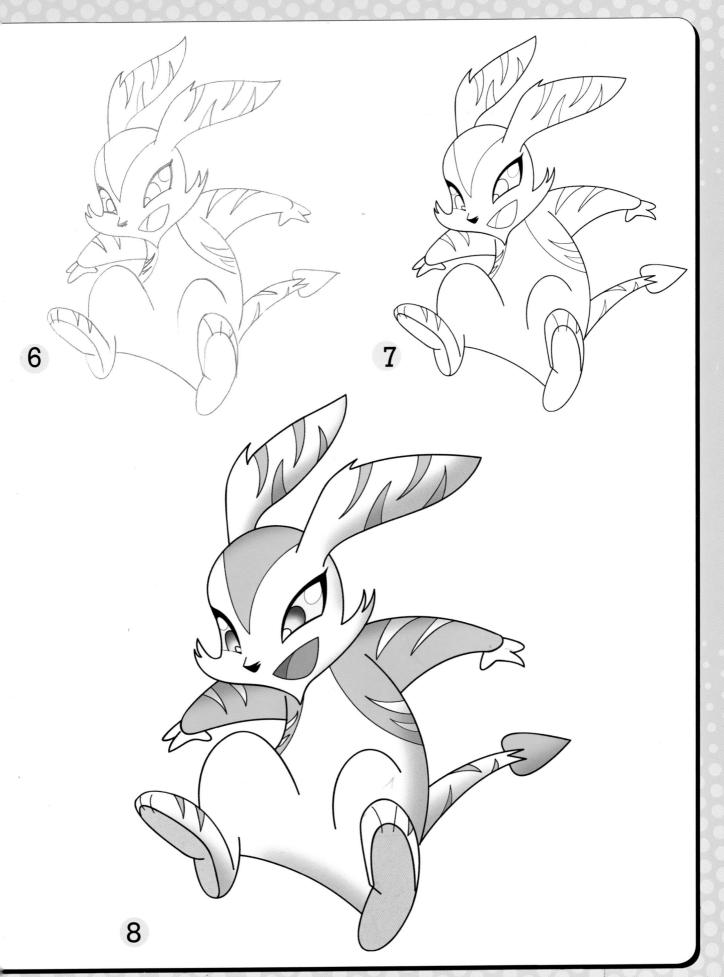

6

7

8

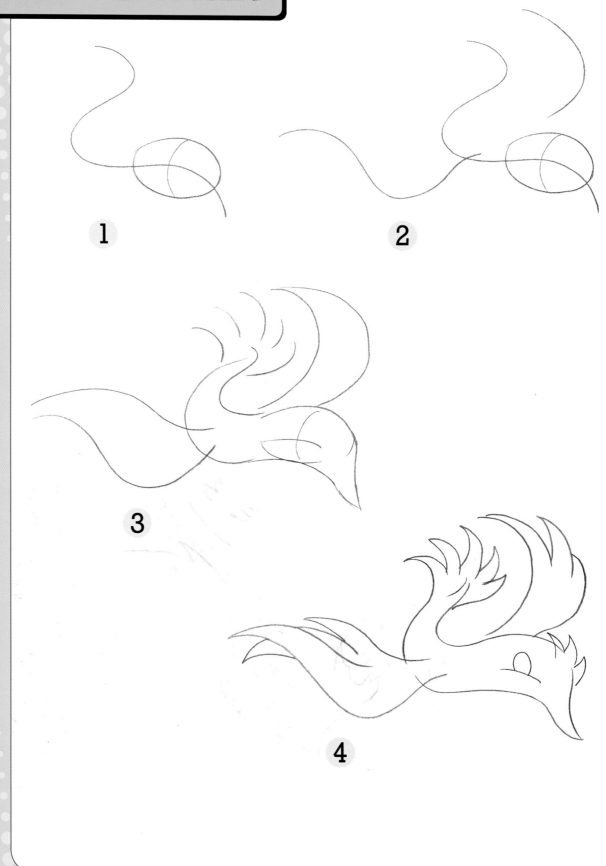

1

2

3

4

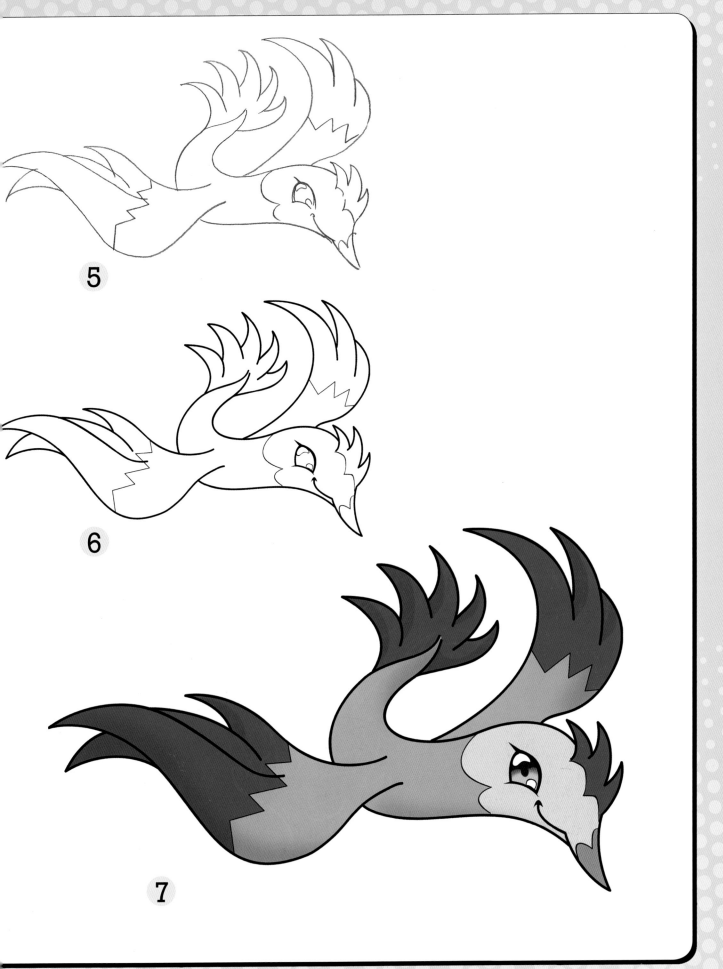

5

6

7

Sharkoraptor

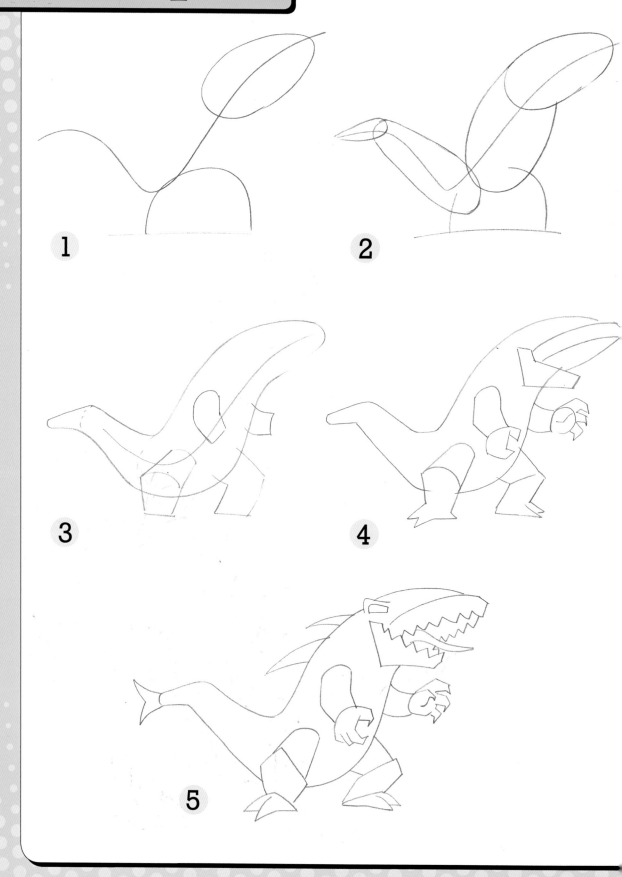

1

2

3

4

5

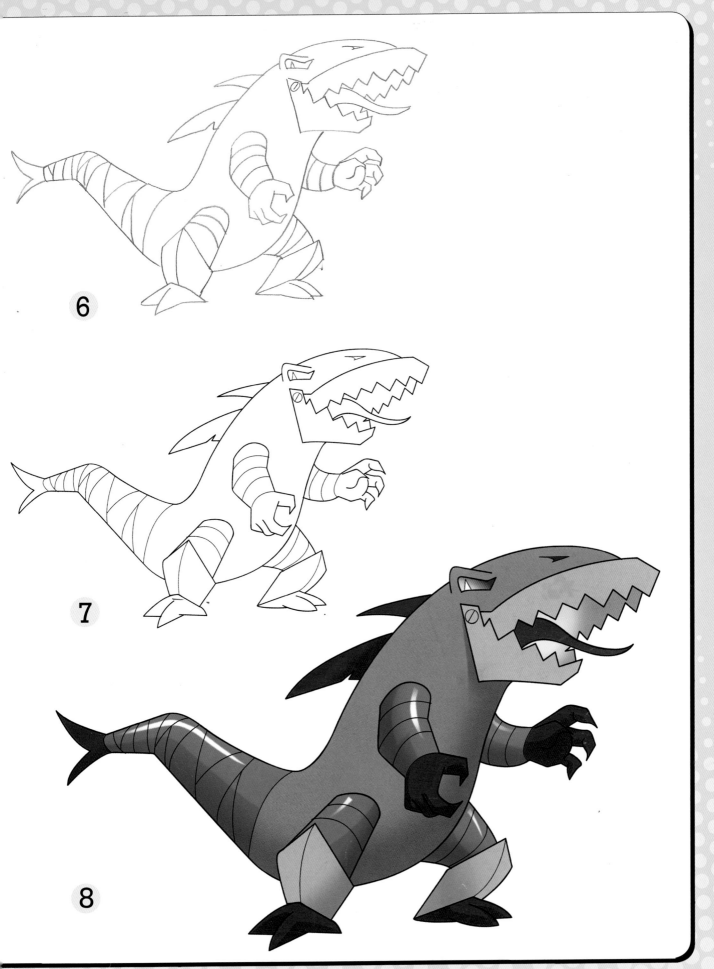

6

7

8

Pitifou

1

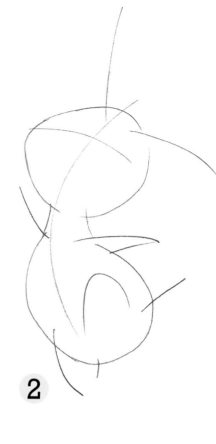

2

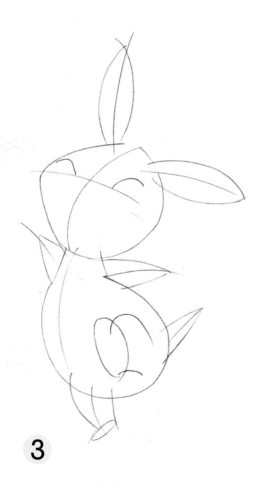

3

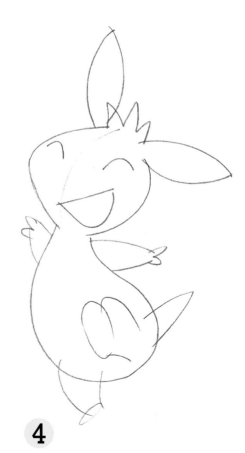

4

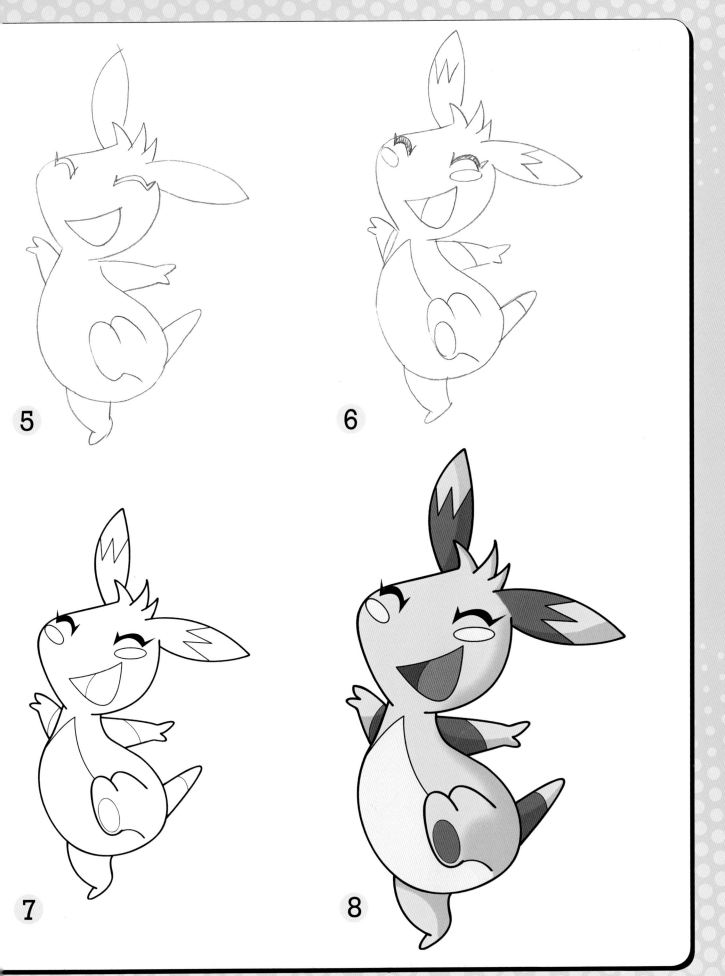

5

6

7

8

Koxxibug

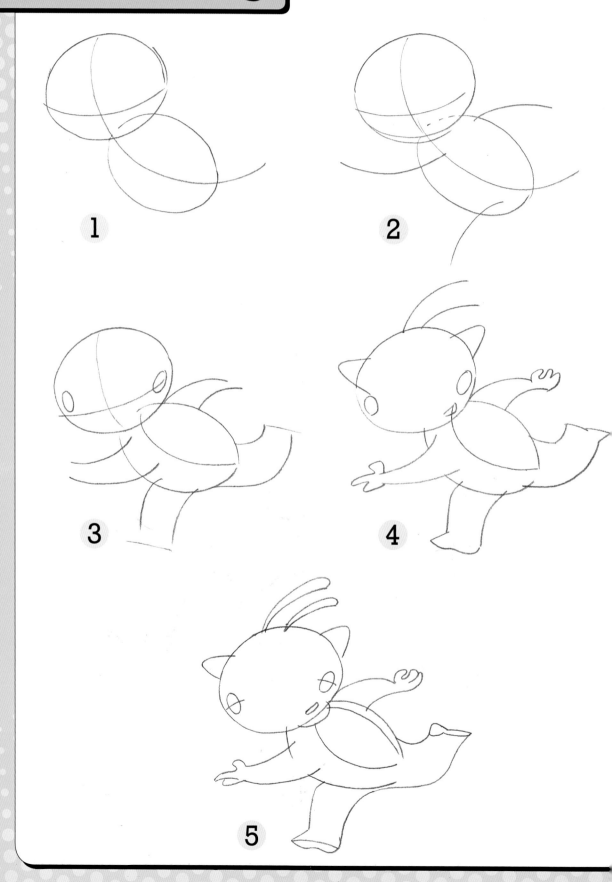

1

2

3

4

5

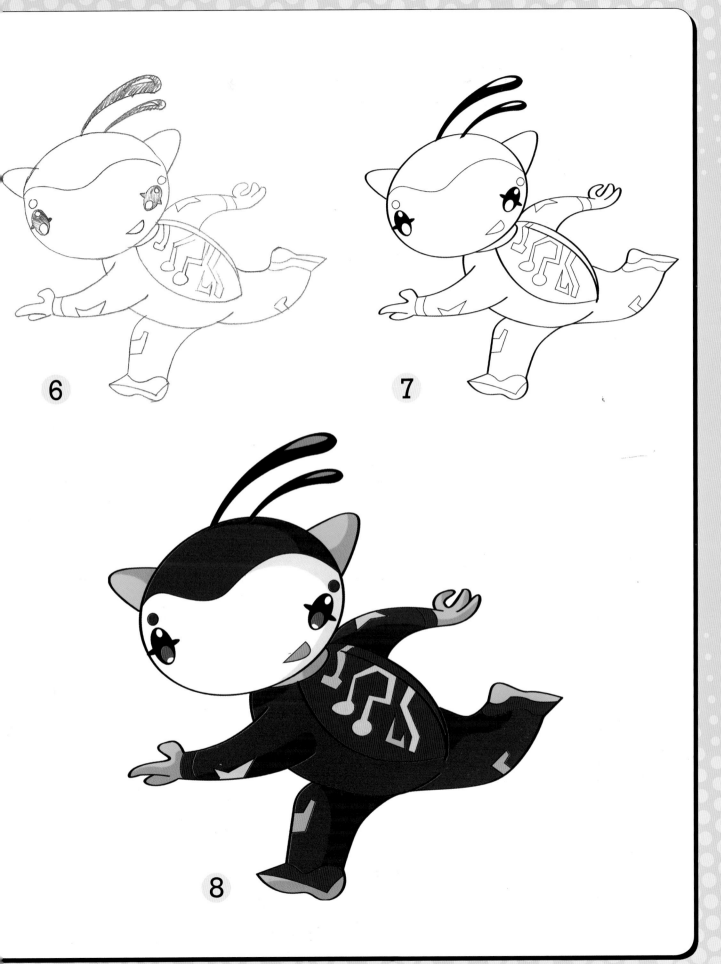

6

7

8

Toufoot

1

2

3

4

5

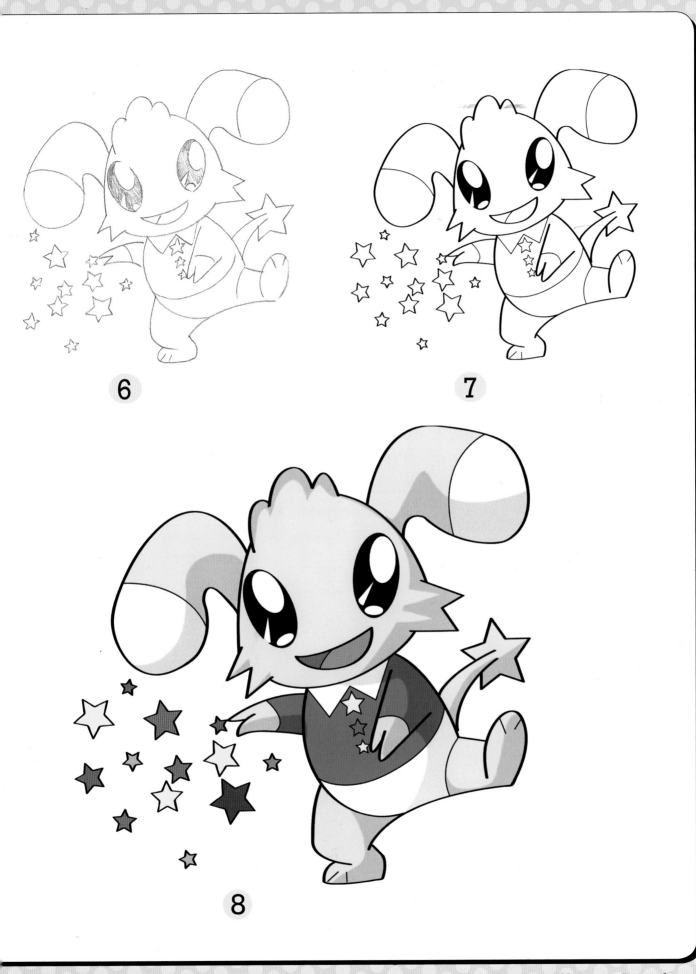

6

7

8

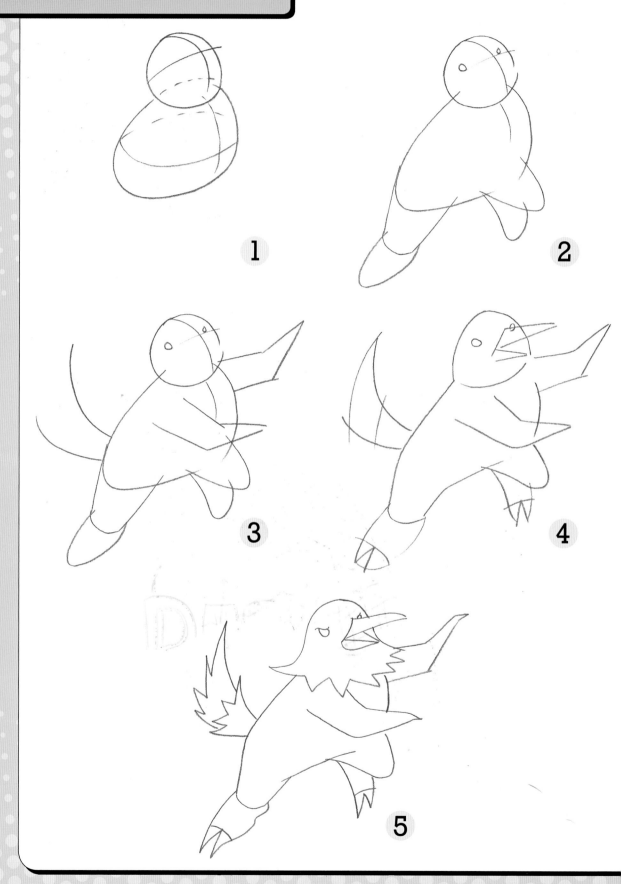

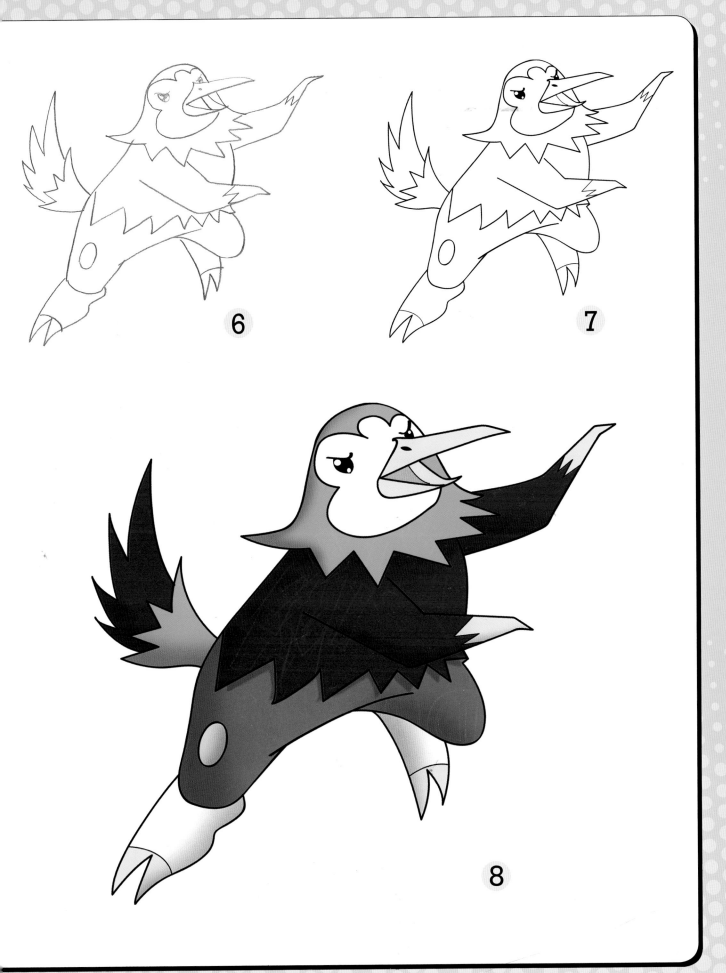

6

7

8

Flamdog

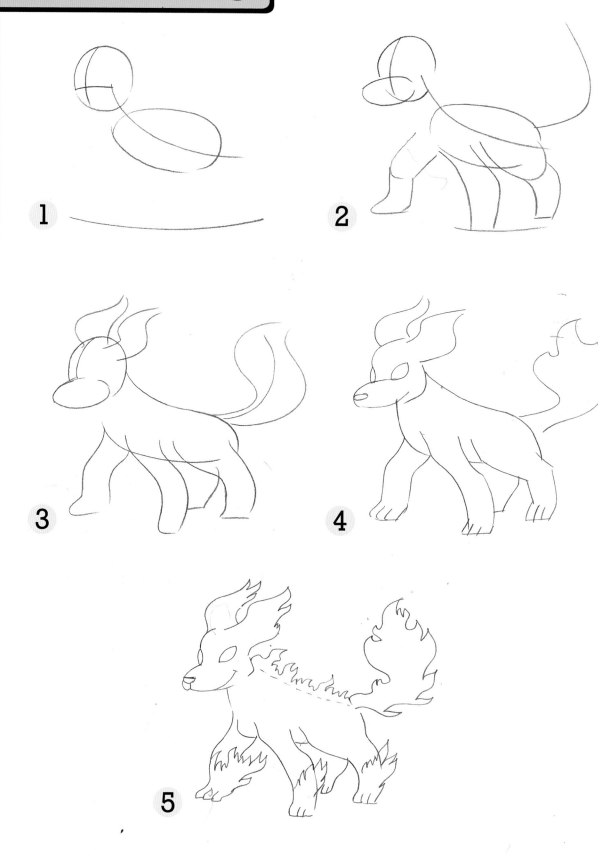

1

2

3

4

5

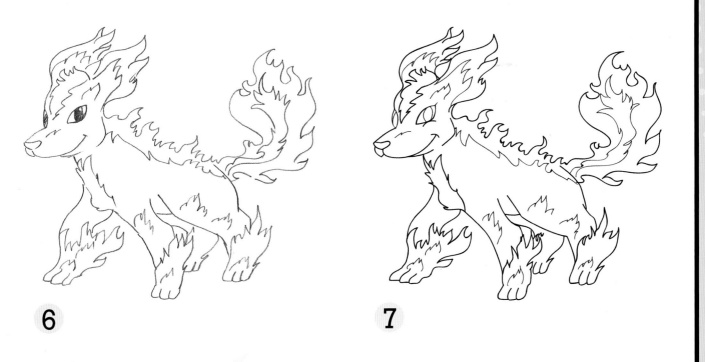

6

7

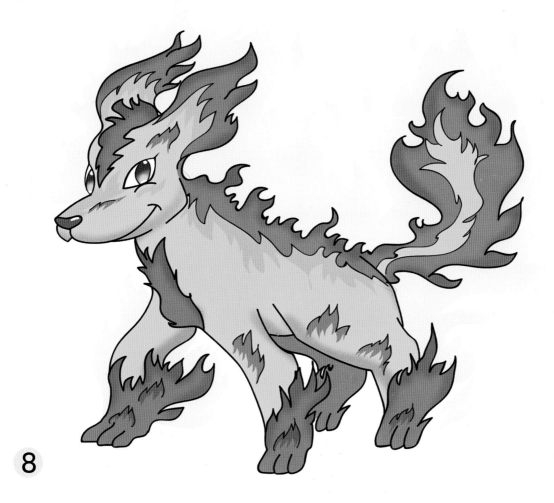

8

Diplodok

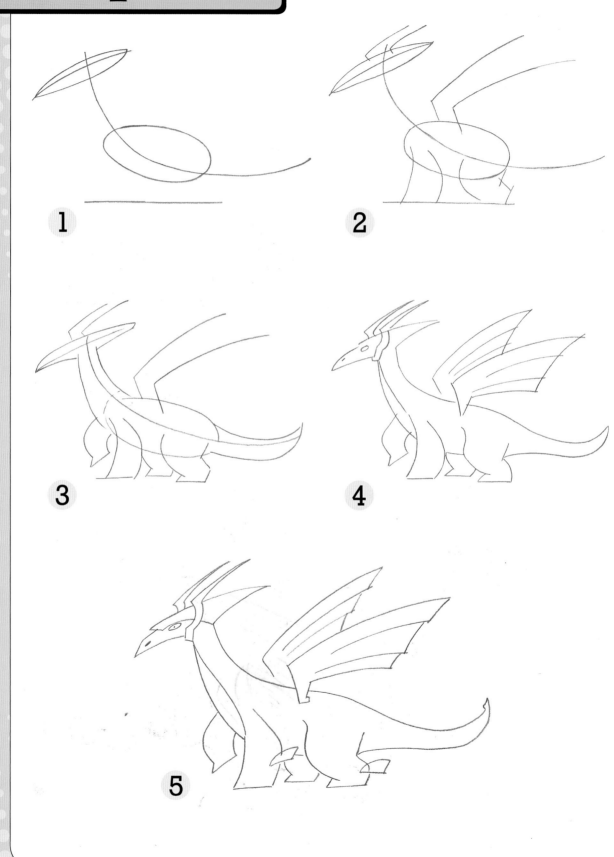

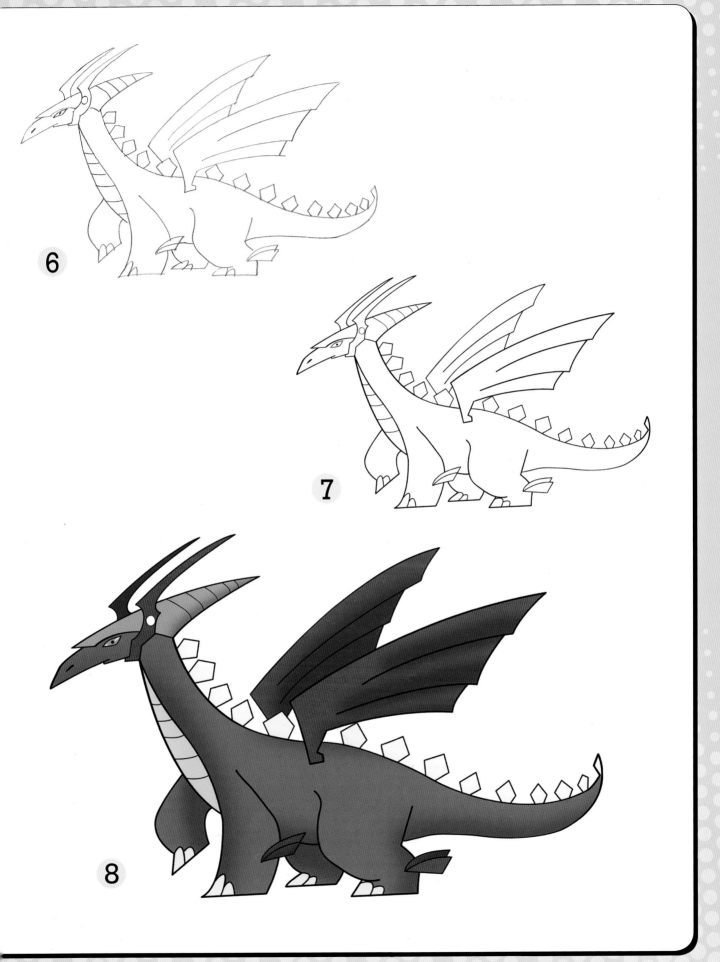

6

7

8

Lokiloko

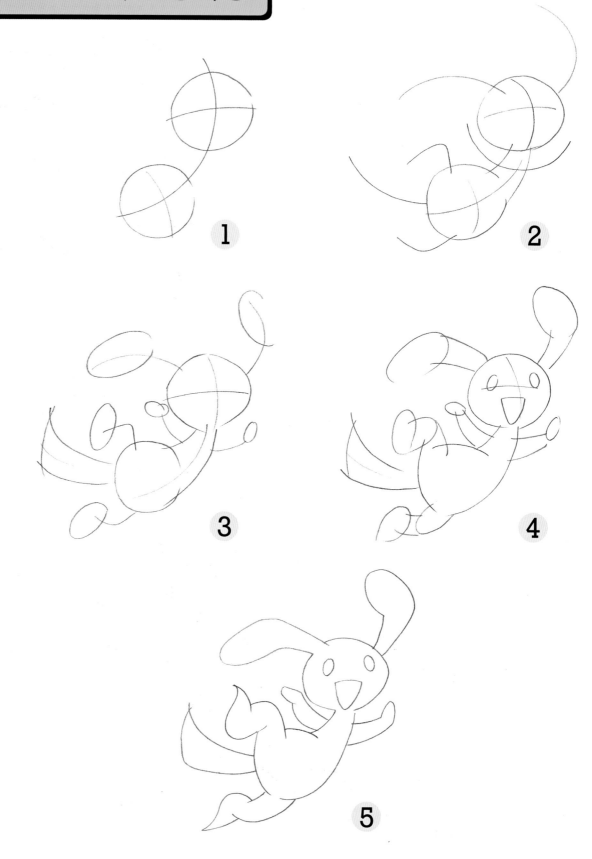

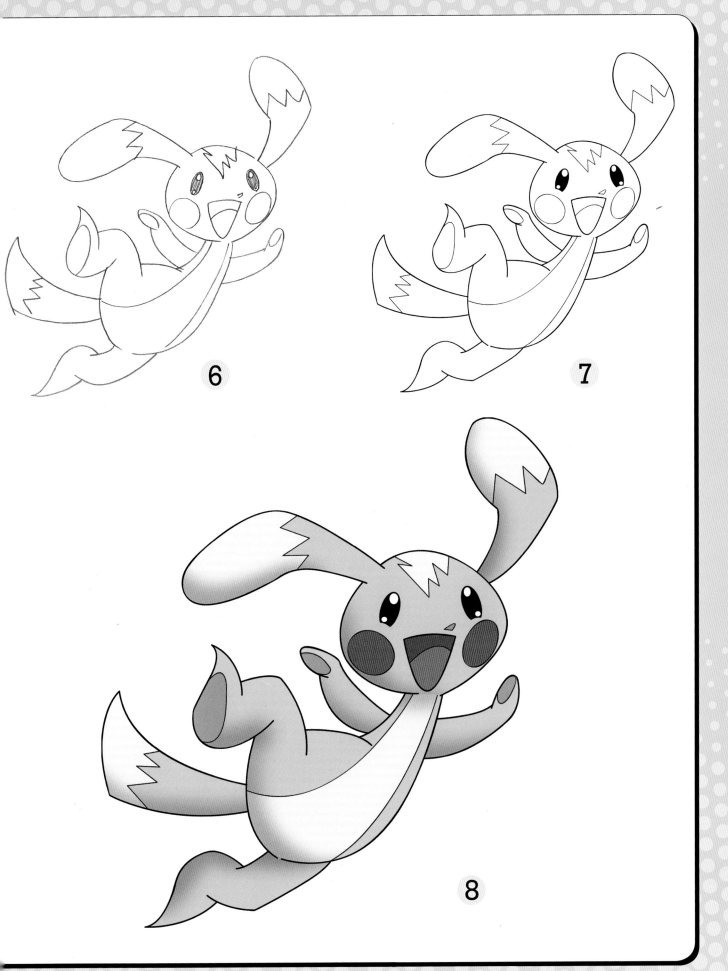

6

7

8

Royalmon

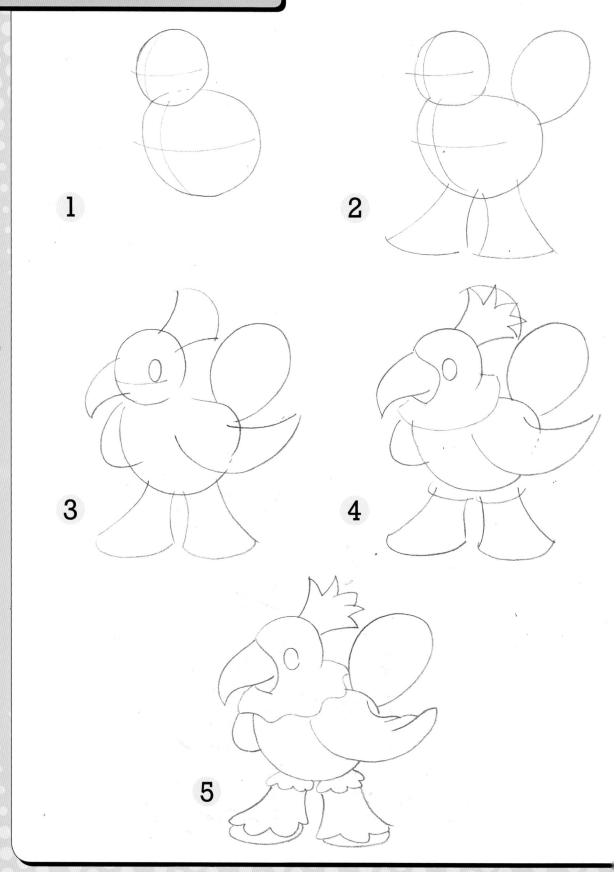

1

2

3

4

5

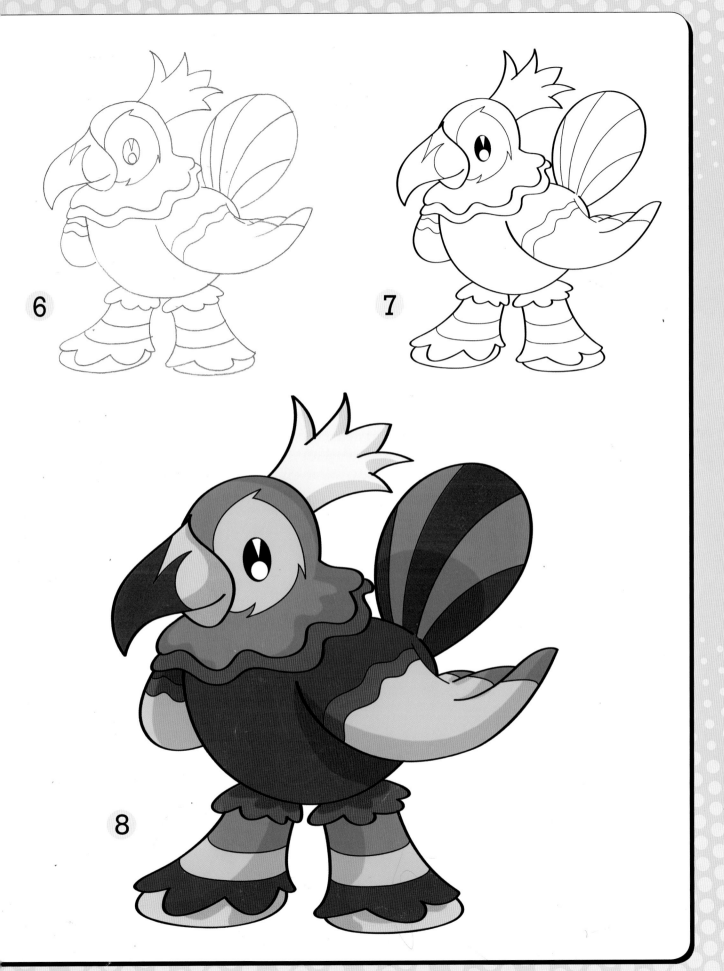

6

7

8

Blikster

1

2

3

4

5

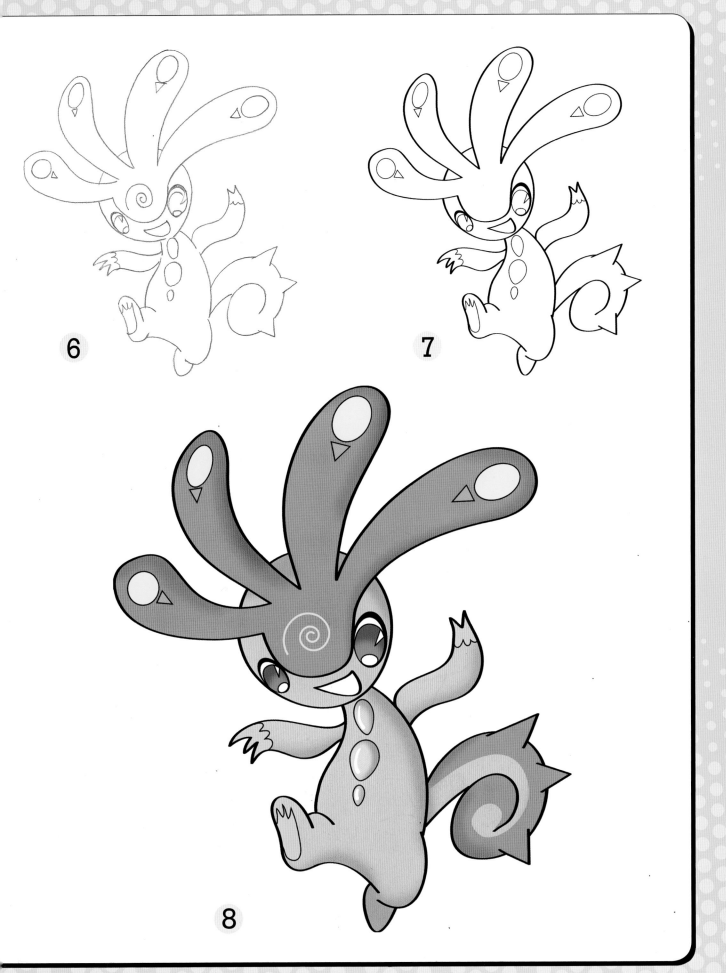

6

7

8

Boulpik

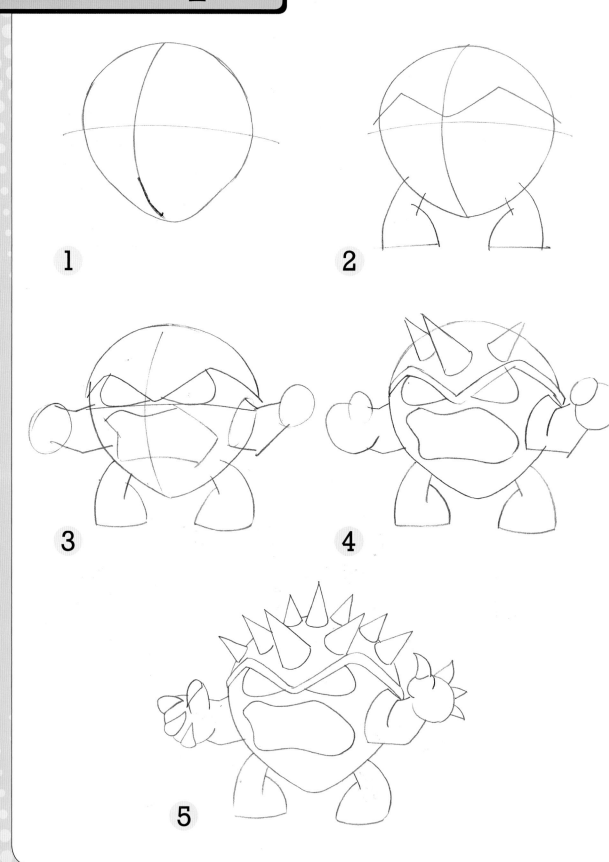

1

2

3

4

5

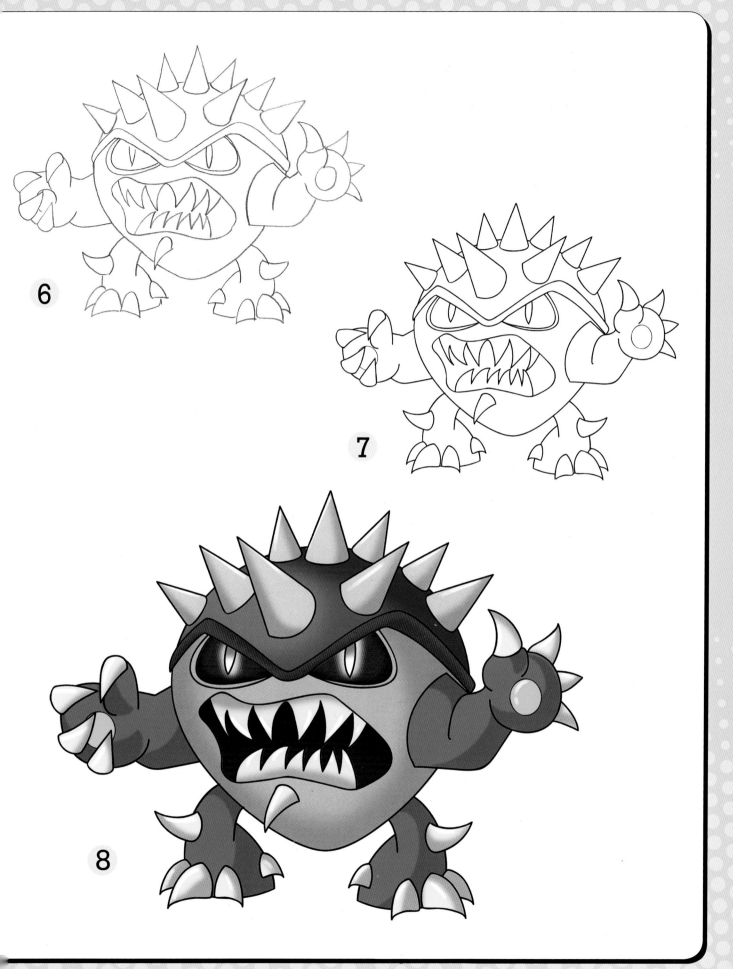

6

7

8

Medusina

1

2

3

4

5

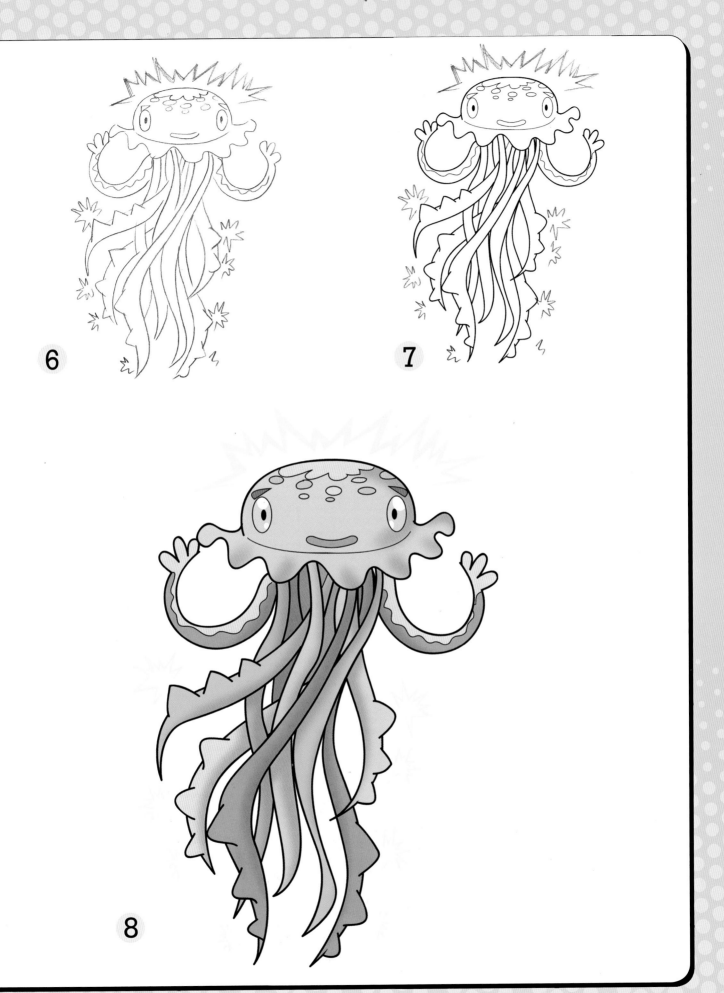

6

7

8

Bekobek

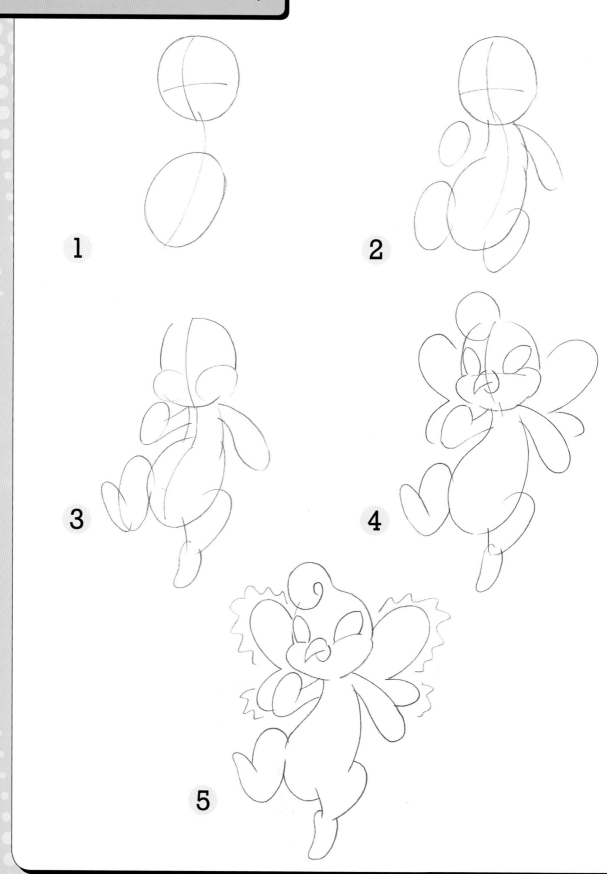

1

2

3

4

5

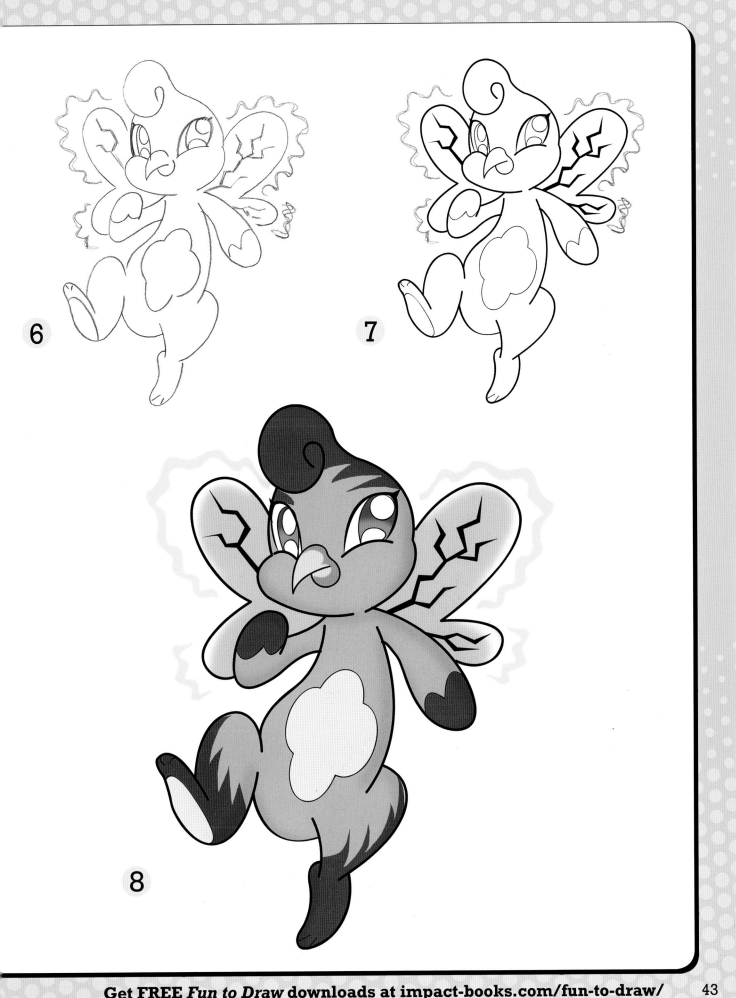

6

7

8

Aristolion

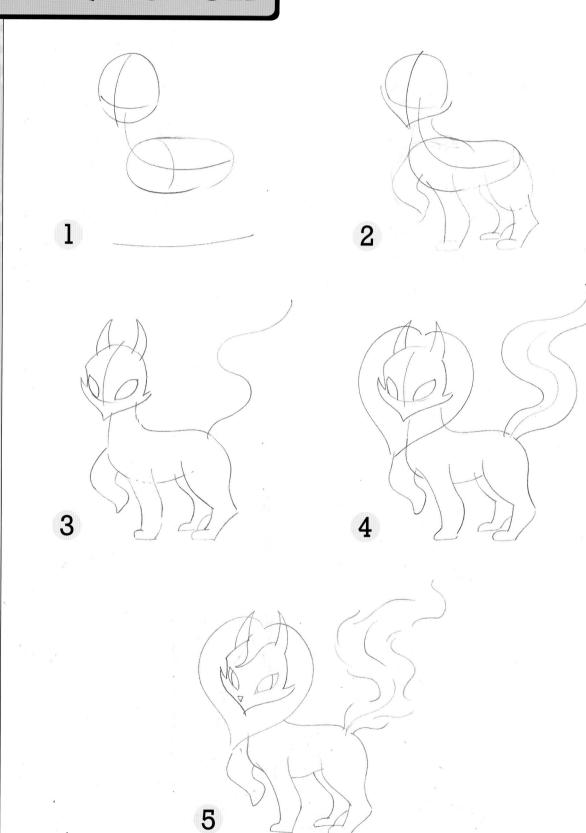

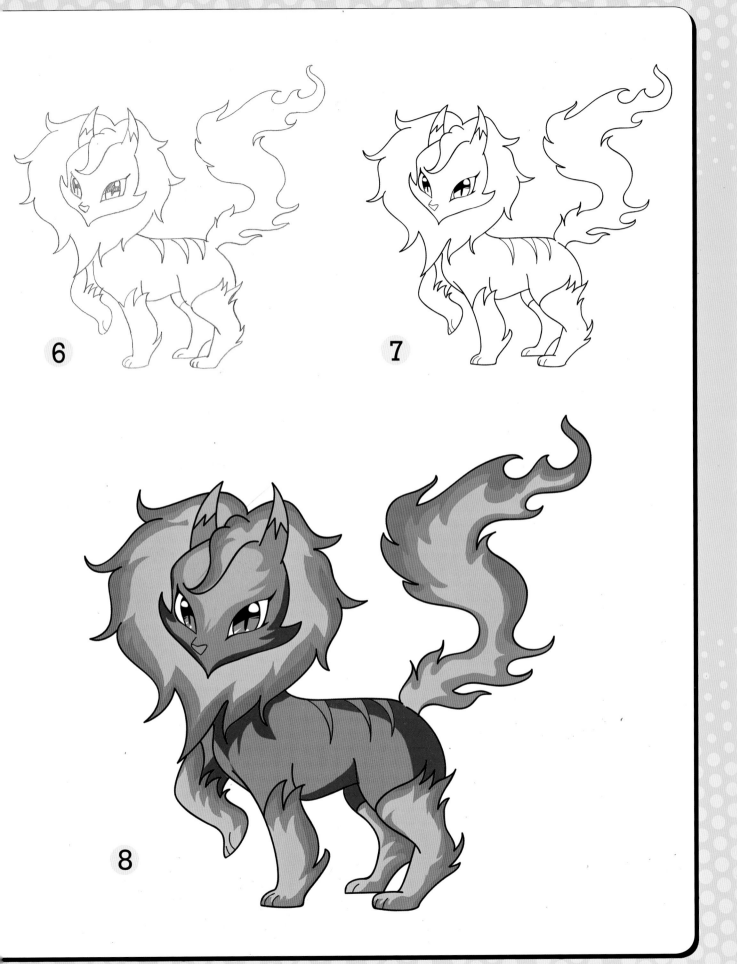

 Other fine IMPACT Books are available from your favorite bookstore, art supply store or online supplier. Visit our website at fwmedia.com.

15 14 13 12 11 5 4 3 2 1

Distributed in Canada by Fraser Direct
100 Armstrong Avenue
Georgetown, ON, Canada L7G 5S4
Tel: (905) 877-4411

Distributed in the U.K. and Europe
by F&W Media International LTD
Brunel House, Forde Close, Newton Abbot, TQ12 4PU, UK
Tel: (+44) 1626 323200, Fax: (+44) 1626 323319
Email: enquiries@fwmedia.com

Distributed in Australia by Capricorn Link
P.O. Box 704, S. Windsor NSW, 2756 Australia
Tel: (02) 4577-3555

ISBN 978-1-4403-1491-9

Cover Designed by Laura Spencer
Production coordinated by Mark Griffin
Originally published in French by Éditions Vigot, Paris, France under the title: Je dessine deshéros rigolos © Vigot, 2007

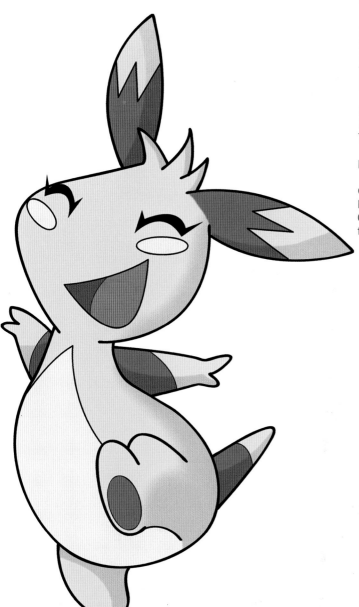

Ideas. Instruction. Inspiration.

These and other fine IMPACT products are available at your local
art & craft retailer, bookstore or online supplier. Visit our website at
impact-books.com.

IMPACT-Books.com

- Connect with other artists
- Get the latest in comic, fantasy and sci-fi art
- Special deals on your favorite artists

Follow IMPACT for the latest news
and chances to win FREE BOOKS!